The Mermaid Chronicles

A Different Way of Looking At The Mermaid Mythos

In Creative Prompt Form

Created by Tabitha Beck

The Mermaid Chronicles
A Different Way of Looking At The Mermaid Mythos
In Creative Prompt Form

Copyright 2012 Tabitha Beck
　　　　　　　With
　　　　　　　Beck Low Curiosities

All rights reserved.

Published by: Beck Low Curiosities
　　　　　　　　　　In cooperation with
　　　　　　　　Rhiannon Venture Services LLC
　　　　　　　　　　　　At
　　　　　　　　1445 Moellering Dr
　　　　　　　　Florissant, MO 63031
　　　　　　　　USA

http://becklowfamilyventure.weebly.com

knittingjourneymanme@gmail.com

No portion of this publication
May be reproduced, stored in a
Retrieval system or transmitted
By any means, electronic,
Mechanical, photocopy, recording,
Or otherwise, without expressed
Written permission of the publisher.

Contact the publisher:
 Rhiannon Venture Services LLC

 http://becklowfamilyventure.weebly.com

 knittingjourneymanme@gmail.com

The Mermaid Chronicles
A Different Way of Looking At The Mermaid Mythos
In Creative Prompt Form

Created By Tabitha Beck

Published by
Rhiannon Venture Services LLC
St Louis, MO USA

Dedication

For Richard—who loves and supports me unconditionally

For Evangeline and Nikolas and Baby Due in July 2012—you are the rock stars of my world

I love you guys.

Table Of Contents

7	How To Play With These Prompts
8	Introduction To The Mermaid Chronicles
9	Once Upon A Time...
10	Creating A Mermaid
11	Group One
12	How Have You Been Altered?
17	You Must Be Trained
19	Battles
21	Injuries Sustained
22	Retirement? Or Death?
24	Escape
26	Life As A Free Mermaid
27	Fertile Times
29	The Life Cycle
31	You, The Mermaid
33	Finishing Up
34	About The Author
35	Also Available From The Author

How To Play With These Prompts

I am not here to lead you through these prompts and tell you how to do things.

My job is to set up a scenario that allows you to explore the concept and the prompt in whatever way best suits you and your talents.

You can do whatever you are compelled to do in relation to these prompts.

You can write, or paint, or dance, or compose, or design, or melt glass, or whatever else you want to do.

Whatever these prompts inspire in you, whatever they inspire you to do, that is the perfect thing to do.

Allow yourself to explore the depths these prompts evoke. If you feel called to try a medium other than that which you are comfortable with, try it. The worst thing that can happen is you don't like it and you get to try a different way.

Feel free to explore these prompts, in any way you choose, as often as you like. Feel free to return to this journey again and again.

Introduction To The Mermaid Chronicles

If you are looking for a darling little mermaid type of mermaid journey, you will be sadly disappointed here.

Another thing is: this is not your typical journey. This is an exploration of a particular topic. Each chapter, each topic, leads you into a particular space, questioning how and why and what at every angle.

This is a different look at an age-old topic. I have gathered together bits and pieces of mermaid lore that is rarely heard in the happy arena where children play.

This is a gritty, morbid look at some theories that revolve around the mermaid mythos that have come up in my studies and readings over the years.

They are presented here for you. See where they take you. See what they bring out in you. See what you can garner from your experience with these prompts.

Once Upon A Time....

Once upon a time, you won the lottery.

You are high-born, a child of rank. A human child. Both male and female children are accepted, and are taken. These precious children are taken between the ages of ten and fourteen years of age.

You are taken from your home. You have no more contact with your family, with your friends.

How do you feel about being chosen?

How do you feel about leaving your old life to enter into this new life?

How do your family and friends feel once you are chosen?

Are you permitted time with family and friends? Or are you taken away immediately?

Do they give you a send-off party or dinner? Anything to mark the occasion?

How do you spend your last night before entering into the training program?

Your training begins. You are kept with other such lottery winners.

What are you permitted to take with you?

What have you packed? What do you want to take with you?

What do you leave behind?

What do you miss from your old life?

What sort of training do you undergo?

How long do you remain?

What are you told?

What are you fed?

How are you treated?

Creating A Mermaid

The scientists, the doctors, whatever you want to call them, divide the lottery-chosen school into two groups.

Each group is further divided into smaller groups.

Different techniques are used on each group.

Some groups submit to surgery.

Some groups submit to chemical alteration.

Some groups submit to a combination of treatments.

Group One

You are in the first group.

You are given a sedative.

How is that administered to you?

A nurse, or someone like a nurse, explains that you will be undergoing a major surgical event to help aid you in your new life.

What else does this nurse tell you?

What does the nurse explain to you?

What details are you given?

How do they care for you before surgery?

How do they care for you after surgery?

How long does your recovery take?

Where do they keep you during your recovery?

Are you in a hospital bed? Are you in a holding tank full of water?

Or perhaps some other place?

How Have You Been Altered?

What sort of mermaid are you?

Some of the tales that have reached us include:

A surgical combination, top half completely human with the bottom half completely fish...

A surgical combination, top half completely human with the bottom half completely whale or dolphin...

A surgical combination, neither wholly human nor fish, but a combination throughout the entire body of human and fish...

A surgical combination, neither wholly human or oceanic mammal, but a combination throughout the entire body of human and whale or dolphin...

Which one of these are you?

Or are you something different, but similar enough to be classified in the same genre?

If you are not one of the surgically enhanced, are you one of the chemically enhanced?

What treatments are you given?

Do the chemicals come to you by way of food?
Are you given regular shots?
Do they treat you with chemicals in some other way?
Are you regularly bathed in chemicals perhaps?
Maybe you are treated with a combination of such techniques?

Different drug treatments enhance different properties.
Look around you.
What do you see?
Are there others being treated chemically as are you?

How long does it take to have your human legs disappear, to fuse into a long sinuous tail?

What changes are wrought that create spines along your spine, along your arms?

What chemicals cause the development of gills? Of fins? Of poisons to be shot from fangs, or something else?

How long does your treatment take? How long does it last?

Does your training continue during this time?

Where are you kept? Are you on dry land, or you in holding tanks?

Are there others of your kind kept nearby?

How are they different and/or similar to you?

Do you talk to one another, no matter how separated you are kept?

What do the doctors, or whatever they are, tell you?

How are you treated? Well? Poorly?

How do you feel, truly feel, about all that is going on, around you, to you?

Do you see others like yourself?

Do you see others similar but unlike yourself?

How are you kept?

Are you kept in schools? In flocks? In murders?

Are you kept isolated? Still healing after surgery?

How does your training continue?

What does your training entail?

What are you told?

Are you in a different group all together?

Are you in the group where they use by surgical procedures, as well as chemical alteration, to achieve their goals?

What happens to you?

What do they do?

Are there others nearby like you?

How does your training continue?

What are you told? What are you taught?

How do you cope? How do you manage?

What is the purpose of all of this?

What is the goal?

What do the doctors hope to achieve? What do you hope to achieve?

Once the doctors, the surgeons, the scientists are done creating you, turning you from entirely human into something more mermaid-esque, are they really done?

During your training period, do they come back to access you?

Do they augment the original treatments?

Are there further surgeries, new chemical combinations, new additions, added as your training progresses?

Do you think this is something the doctors had planned prior to your change? Or does it feel more as if they are making things up and trying new things as they go along?

Do policies change during your training?

Does your training change? Are there new techniques taught? New information given that contradicts the old?

Are you allowed to have free time with the others?

Are there many of you? Does there seem to be more or less, now that the changes have been made and the new bodies created?

Are you still kept in separate groups? Separate classes?

Are you segregated by task that you are to take up once training is complete? Or is everyone taught the same basics together?

You Must Be Trained

What is it like, to go from a land-dwelling air-breathing human to an ocean-dwelling fish-like creature?

Are you still mammal enough to need to breathe air? Or are you one that breathes oxygen from the water, like the fish?

How are you taught to live in the water?

How are you taught to breathe in the water?

How are you taught to handle the challenges of life in the sea?

Are you forced to stay in the ocean? Or can you travel through fresh waters as well? Is there a process you must undergo in order to change from one to the other?

What are the challenges you face living underwater?

Where do you live now? Where will you live once your training is complete? Have they told you yet? Do you have any ideas?

Are you taught to hunt for food? Or are you fed by the doctors, or whatever they are?

What are you taught about interacting with other creatures under the water?

What are you taught about interacting with other creatures above the water?

What are you taught about interacting with others of your own kind?
Are relationships between the altered permitted? Encouraged? Tolerated?

What are you taught about your future? Your choices? What will happen when your services are no longer necessary? Is that even a choice?

Tell us about learning to fight underwater.

You learn to fight what? Other creatures like yourself? Huge ocean creatures? Natural disasters?

Tell us about learning to interact with other creatures, both underwater and above water.

At what point, if ever, do you make contact with humans, other than your handlers, the doctors and whatever?

Do you ever seek to re-establish contact with family or friends from your past?

Do you remain in the company of your new compatriots?

How do you react to others of your own kind? To other non-threatening creatures? Towards the doctors, the handlers, the whatever?

How do react to yourself? How do you feel about yourself?
How do you feel about what's going on? About what you are being put through...and why?

Battles

You, and your new kin, have been created in order to protect the land of your forefathers. This means you must fight. You are the elite naval force that attacks from beneath the waves, who attacks beneath the waves, all intruders and attackers.

With what are you required to do battle?
Why?

Are there great ships that come in to attack your land that must be repelled?

You have been trained to fight off just such an intruder.

Most of your training focuses on natural predators: giant octopus, hoards of squid, masses of jellyfish, sharks, oceanic crocodiles, plesiosaurs, other huge swimming reptiles…and other such predators that attack anything around and near the land, creatures that make the area too forbidding for traders coming in by sea, or for fisherman, or for any other citizen of the land.

So, tell us about these battles.

Tell us how you battle, alone, octopus.
Tell us how you battle, as a group, octopus.

Tell us how you battle, alone, squid en masse.
Tell us how you battle, as a group, squid en masse.

Tell us how you battle, alone, jellyfish masses.
Tell us how you battle, as a group, jellyfish masses.

Tell us how you battle, alone, giant sharks.
Tell us how you battle, as a group, giant sharks.

Tell us how you battle, alone, great crocodile.
Tell us how you battle, as a group, great crocodile.

Tell us how you battle, alone, plesiosaur.
Tell us how you battle, as a group, plesiosaur.

Tell us how you battle, alone, other prehistoric swimming reptiles.
Tell us how you battle, as a group, other prehistoric swimming reptiles.

Tell us how you battle, alone, human marauders.
Tell us how you battle, as a group, human marauders.

Injuries Sustained

During all these battles, surely there are injuries to the mermaid populace.

How are they treated? The mermaids? The injuries?

If you have slight injuries, do you report them? Are they taken care of?

If someone is fatally injured, is the body returned to the handlers? Or is it left to the ocean?

If you are taken in for extensive care, is that all that happens?

Is there more than mere healing going on?

Are mermaids given upgrades? Even if they are not injured, do these upgrades happen?

What sort of technology is used to care for the wounded?

Are all mermaids returned to duty once they have been worked on and healed?

Are some mermaids humanely 'retired' due to the extent of their injuries? Or perhaps because of their lack of bravery or talent in battle?

Are the bravest warriors rewarded in some way?
What are the rewards?
Are there perhaps ceremonies honoring these warriors?
Or are there other types of rewards?
Upgrades? Romance? Luxuries?

What does a mermaid consider to be a luxury?

What about the fallen? Are they honored?
Are they commemorated in any fashion?

What about you?
What's happened to you?
What injuries did you sustain?
What upgrades were you given? If any?

What about kin close to you?
Other mermaids?
What happened to them?
What did you see?
What did you experience?

Retirement? Or Death?

You have already noticed that all mermaids do not always last long in this service to their land.

Sometimes it is the battle. Sometimes it is the ocean. Sometimes it is other mermaids.

What happens to these mermaids?

Do they retire willingly? Are they taken away? Are they sent somewhere?

Are they taken apart and used to make other mermaids? Other creatures? Other creations?

There are many scenarios, many possibilities.

Tell us about an ordered destruction. As in the handlers order you, or several mermaids, to destroy a particular mermaid.

Tell us about taking a mermaid in to the handlers for termination.

Why would the handlers and doctors request a mermaid for termination?
Is it because battle injuries were too extensive?
Is it because the mermaid in question is too head-strong? Disobeys orders? Goes too far out on a limb to follow orders? Is too unpredictable?

Could the handlers and doctors be culling the herd? Weeding out outdated models? Making room for the new upgrades and improved creations?
Could they be removing various and what seems like random members of the clan in order to keep everyone guessing, to keep everyone obedient?

Tell us about these scenarios.
Tell us what you've seen.
Tell us what you've heard.

What about the mermaids that run away?
What happens to them?
Are they chased? Are they captured? Are they hunted?
Is there a specific group that goes after the deserters?

Why would these mermaids flee?
Why would they run away?
What makes them take this way out?

Escape

This time it is you who runs away.
This time, you flee from the handlers and their wares.

Why do you do this?
Aren't you afraid of the repercussions?
What finally forced your hand and made this flight inevitable?

Where do you go?

How long do you run?

Do you go alone?

Do you go in a group?

Is there a known place to meet up with others?

Do you have a specific destination in mind?

How do you survive?

How long do you look over your shoulder, awaiting some attack, or recapture?

What are you thinking?

What happens if you don't run away?
What happens if you stay?

What happens if you stay until the land you protect is itself destroyed by forces beyond your control?

Do you know what destroyed the land?
Was it a volcanic eruption?
Was it cataclysmic earthquakes?
Was it a meteor from the sky?

Was it outside human forces?
Enemies attacking and destroying with bombs and guns and cannons?
Was it the scientists playing with things they had no business playing with that caused the issues that brought about the downfall of the land you all serve?

Why do you stay as long as you do?

What do you do once the land is destroyed?

Do you help survivors? Do you give humans aid? Do you help them reach other land? Do you protect them on their journeys?

Do you stay around the land, trying to take care of the land even now, protecting it? Still doing the job for which you were created?

How do you feel when the land is destroyed?

What choices do you make once your land is destroyed?

Do you stay close to the land?

Is there a group of you who stay?

Do you strike out on your own?

Is there somewhere else you go?

What happens to the group once there are no more handlers?

Are there arguments about leaving? Does someone try to be in charge, to take over, to lead the group?

What do you do?
What do you think?
Where do you go?

Life As A Free Mermaid

Now you are truly free.

The land no longer exits.

The survivors are all gone, taken care of, transplanted.

Do you remain with a group?

Do you become a solitary creature?

What do you do?

How do you live?

Where is your home?

What do you eat?

How do you survive?

What are the challenges of your life?

Do you travel?

Do you wander?

Do you stay in the same place?

Do you interact with others, whether as a member of a group, or all alone?

What is your life like?

What is your existence like?

Fertile Times

Can the mermaid population sustain itself?
Are they able to create more mermaids?

What long-lasting effects do the treatments from the doctors remain?

Are all mermaids capable or reproducing? Or only certain types?

Is there an issue between the type of male and the type of female attempting to procreate together?

It is true; all mermaids suffer from fertility issues. Different groups of mermaids have different characteristics physically, including reproductively.

Not only do their bodies, their minds differ. Not all of the alterations made to the mermaid populace were merely physical. There were many, many mental manipulations as well.

Tell us about the following examples of different reproductive groups within the mermaid population:

Tell us about the egg-laying mermaids.

Those who lay one single egg at a time.

Those who lay hundreds of eggs at a time.

Tell us about those who guard and protect their eggs.

Tell us about those who abandon their eggs.

Tell us about those who are oblivious to the egg laying process, who don't know what is going on.

Tell us about those who give birth to live young.

Tell us about those who bear a single live young.

Tell us about those who bear multiple live young at one time.

Tell us what you have been through.
Tell us what you have undergone.
What have you seen?
What have you noticed?

The Life Cycle

We have entered into the life cycle of the mermaid here.

What happens to each newly created mermaid infant?

What happens to each creature that hatches out of one of those single eggs?

What happens to each creature that hatches out of one of those hundreds of eggs?

What happens to the ones who were live births?

How are these infants raised? Are they raised by someone else or do they raise themselves?

For those who hatch, do they have a life cycle similar to octopus?
Do they erupt from their eggs and float gently upon the ocean's waters, developing quickly, hiding from predators?

For those who are live births, is there someone there to take care of them?
Do they follow their parents like baby whales?
Do they drink mother's milk?

What do these creatures look like? Are they visibly human in part? Or do they take more after the fish-side of the parents? Or the whale-side?

How are these creatures different from their parents?
How are they like their parents?

Do they have the same mentality of their parents?
Do they have that human mental make-up?
Or are they more of an ocean-dweller?

What happens once these children grow up and start reproducing on their own?

What is their childhood like?
For those who hatched and survived to adulthood?
For those who were born live? Those that were cared for by parents?
Those who were abandoned to the sea after birth?

How do they learn? What do they learn?

How do their skill sets differ from that of their parents?

Without the land to protect, what jobs exist for these mermaids?

What do they look like?
The hatched ones? The live birth ones?

Do they have the same behaviors as their parents?
Whether hatched or live born?
Whether taught by an adult or left to their own devices?

What do they eat? Does that change throughout their lives, as they grow?

Do these young ones find each other? Do they prefer to live in groups? Are they solitary? Do they group together for mating purposes? Do they pair up and live that way, as a family unit?

Does that depend on the type of mermaid they may be?

Can they interbreed better or more readily than their parents?

Do they have the same inherent medical and/or genetic issues that their parents had?

How have these creatures evolved more than their parents?

How do they live?

How do they survive?

How do they carry on the species?

You, The Mermaid

What sort of mermaid do you become after the loss of the land?

Do you retain your traces of humanity? Or do you embrace what you are, what you have now fully become, a mermaid?

Do you hold a grudge against the humans who turned you into a mermaid? Or are you grateful for the change?

Are you one of the mermaids who taunt sailors and lead them to their deaths on rocky shores?

Or do you stay as far from humanity as possible?

Do you interact with humans on any level?

Do you help out when you can?
Do you allow those you save to know who and what you are?
Or do you hide that from them?

Do you deal with mermaids who are your polar opposite?
How do you deal with them?

How do you meet them?
Are you part of a group?
Do you agree with the group?
Or do you stay alone, on your own?

Tell us about your day to day life.
Tell us what you when you awaken in the morning.
Where do you sleep?
How careful do you must you be to ensure that you are safe and protected from predators?

What do you eat?
How do you obtain that food?
How often do you eat?

What do you do during the day?
Where do you go?
Who do you talk to?
Do you have friends?
Do you have specific places you visit?

Do you have special places?
Special activities?

What goes through your mind?
About your past?
About your present?
About your future?

Do you have dreams, nightmares, about your past?

Do you miss your human self?
Your human family?
Your human friends?

Do you miss being part of the group, part of the land's military?

Do you visit the land periodically, where it once floated?

Do you encounter any of the old predators?
Do they hunt you?
Do they seek you out?

What goes on with you?

What is your life like now, these days?

Finishing Up

Is this the end of this story?

That is all up to you.

Do you have more questions? Other questions?
Feel free to explore them as well.

Delve into this delicious topic, this alternate world.

There is an entire world of the mermaid unknown, unseen, and uninvented.

Know this world for yourself.

See this world for yourself.

Invent this world for yourself.

Allow yourself to become a part of this world and explore it.

Allow this realm to spark your creativity in new and unusual ways.

Be true to you, even while you become a part of this new world.

About The Author

Tabitha is an experiential journey creatrix.

She sews. She collages. She writes.

She paints. She draws. She knits.

She designs. She crochets. She meditates.

All the while homeschooling herself and her children.

To find more of Tabitha's work,
As well as that of her family,
Visit their website:

http://becklowfamilyventure.weebly.com

Contact Tabitha directly at:

Knittingjourneymanme@gmail.com

Also Available From The Author

The Wisdom Tree:
　　　　This is a gentle work book, suitable for children, exploring the creation and the care of your own wisdom tree.

Fourteen:
　　　　Twenty-six years ago, I wrote these eighty-four poems. Twenty-six years, I've waited to be strong enough, in and of myself, to let these poems fly out, loose in the world.

Be The Seed
　　　　This short work book guides you through the process of choosing a dream or a wish, turning it into a seed, planting it and nurturing it to fruition.

The Women Of Spirit
　　　　Twenty-one full-color paintings done in the style of Cheryl Irwin. This is a book of photographs of original artwork done by Tabitha. There is no accompanying text. Enjoy viewing and interacting with the Ladies in these paintings at your leisure without any other input to cloud your own unique vision.

Pathway For A Princess
　　　　This is a journey suitable for both children and adults. Become a princess and explore the kingdom as you go about on a quest.

Mermaid
　　　　This journey is suitable for both children and adults. Poseidon has sent you on a series of quests, in both salt and fresh water. Swim through oceans and rivers to accomplish your goals and win your reward.

The Raven Journey
　　　　This is an experiential journey Work Shop. Explore your inner spiritual world as you take this Raven Journey into many worlds. Open-ended prompts allow you to walk through the doors and see what lies in wait on the other side.

How To Create Your Own Spirit Doll
　　　　This is a truly interactive course where you decide what sort of doll you want and need. You are given exercises to help you access your own Inner Wisdom to create an object that is truly original and imbued with your own love and energies.

Find Out More Here:
http://becklowfamilyventure.weebly.com/books.html

www.ingramcontent.com/pod-product-compliance
Lightning Source LLC
Chambersburg PA
CBHW080230180526
45158CB00009BB/2753